THE OFFICIAL
DUNE
COLORING BOOK

INSPIRED BY
FRANK HERBERT'S *DUNE*

ACE
NEW YORK

ILLUSTRATED BY

TOMISLAV TOMIĆ

COLORED BY

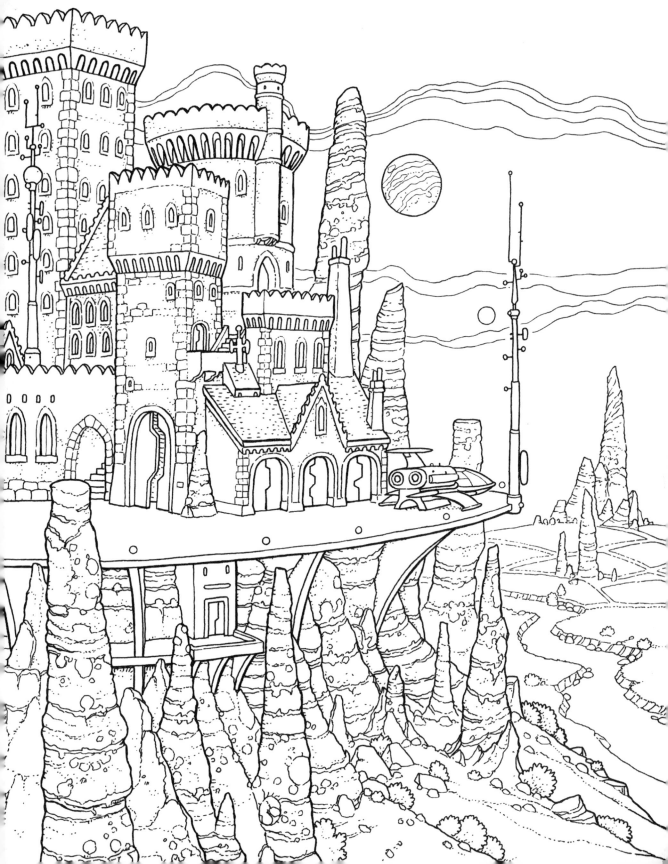

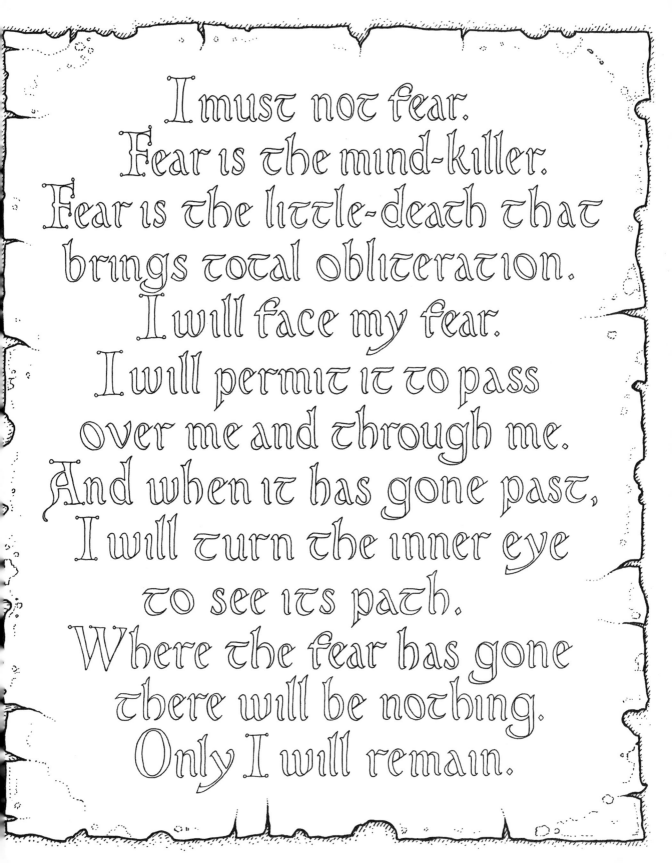

I must not fear.
Fear is the mind-killer.
Fear is the little-death that
brings total obliteration.
I will face my fear.
I will permit it to pass
over me and through me.
And when it has gone past,
I will turn the inner eye
to see its path.
Where the fear has gone
there will be nothing.
Only I will remain.

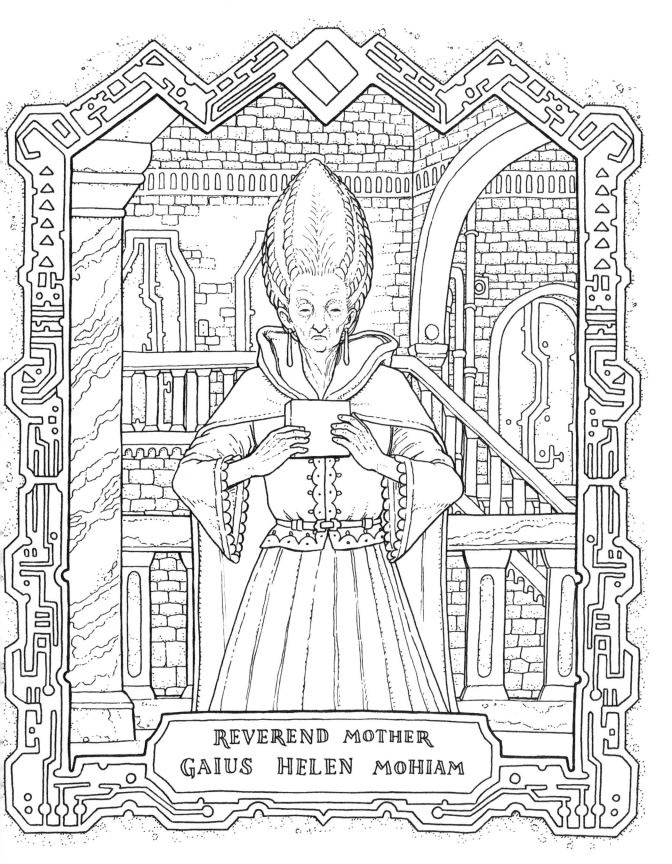

REVEREND MOTHER
GAIUS HELEN MOHIAM

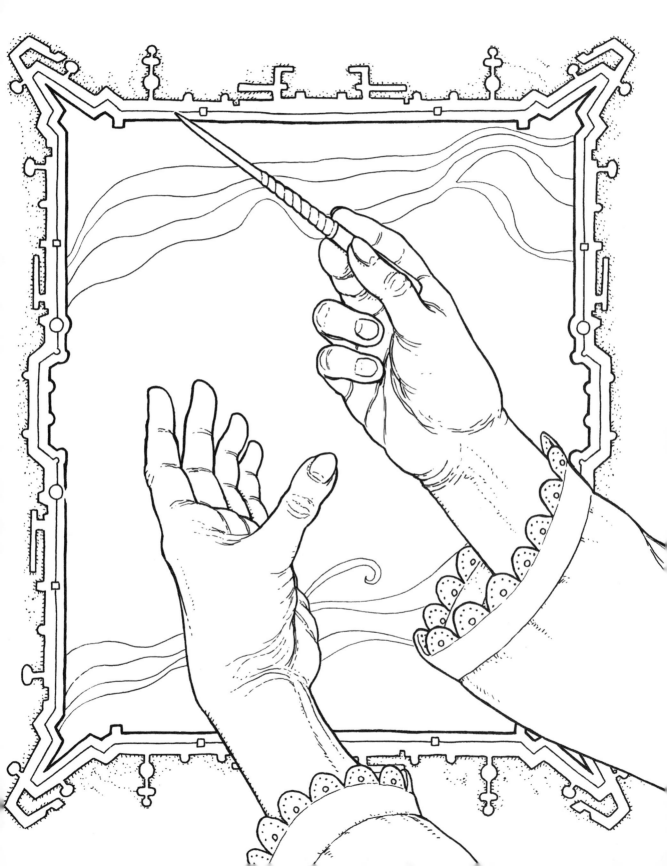

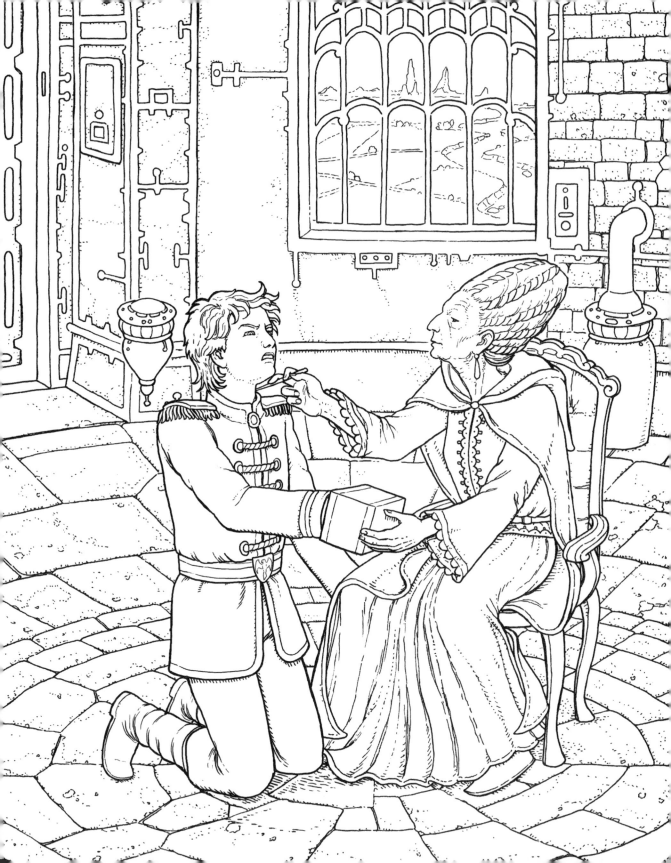

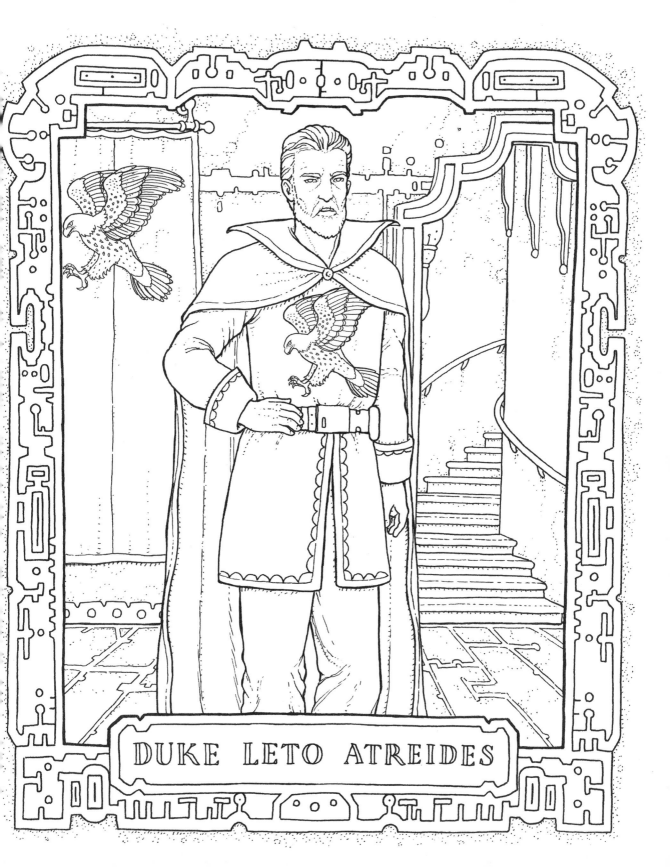

DUKE LETO ATREIDES

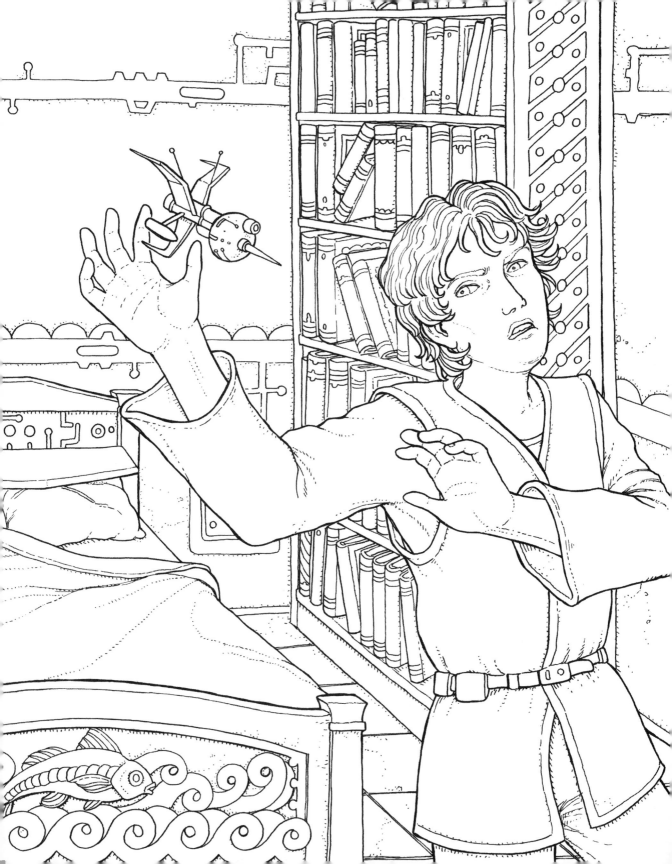

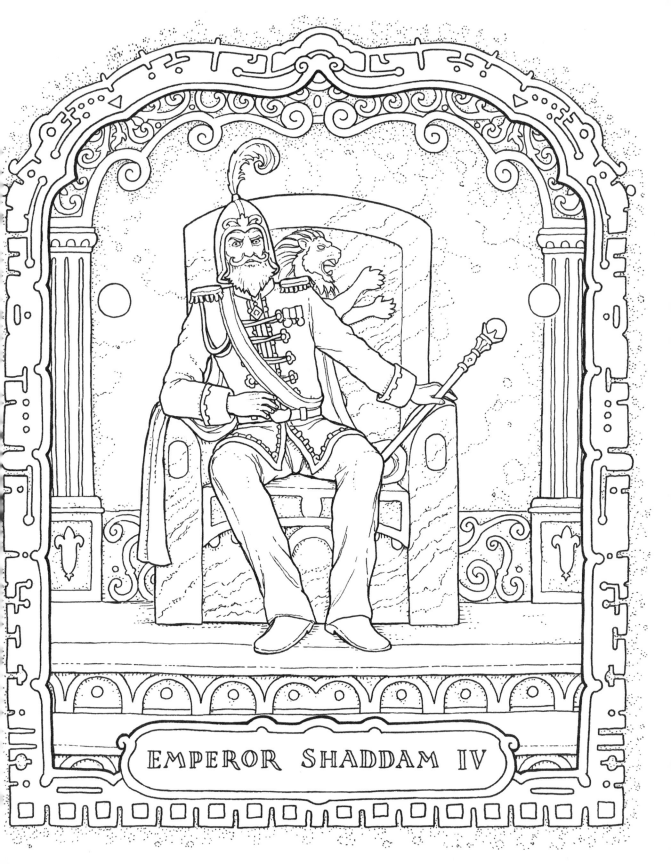

EMPEROR SHADDAM IV

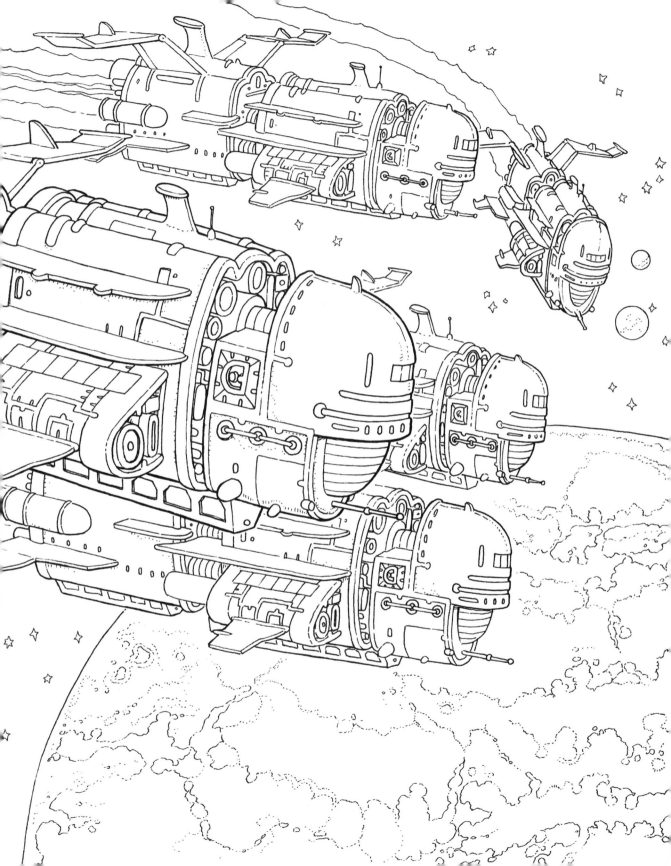

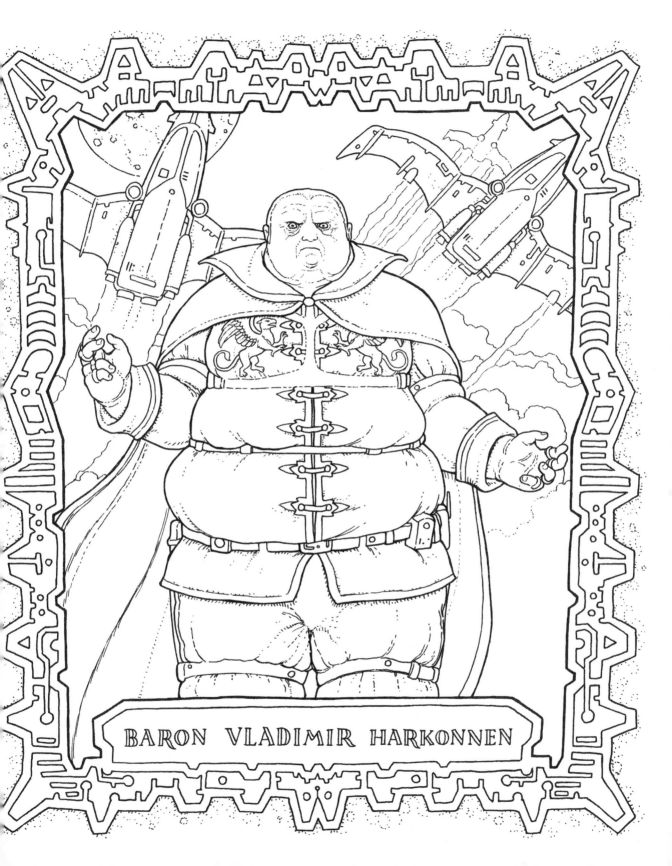

BARON VLADIMIR HARKONNEN

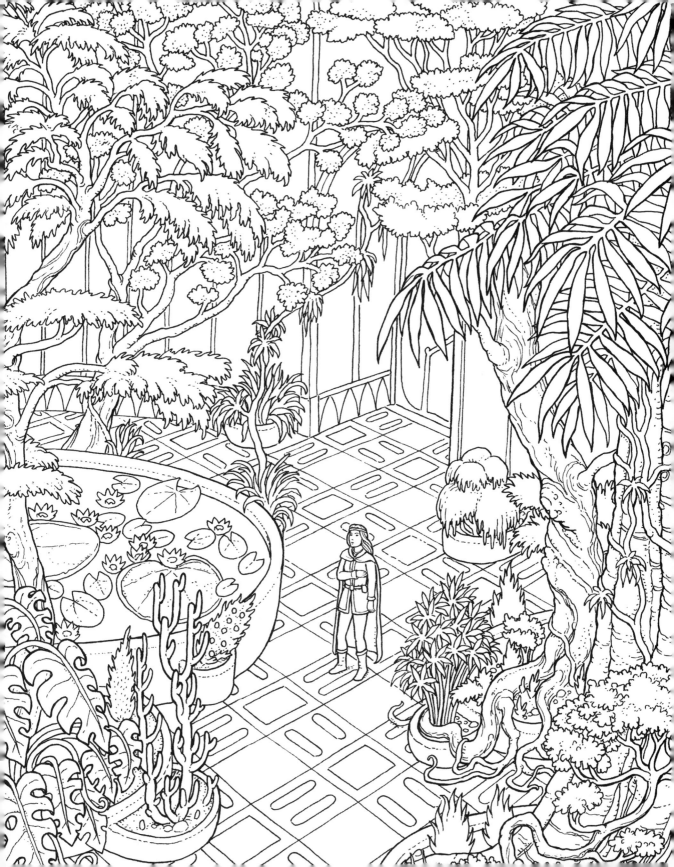

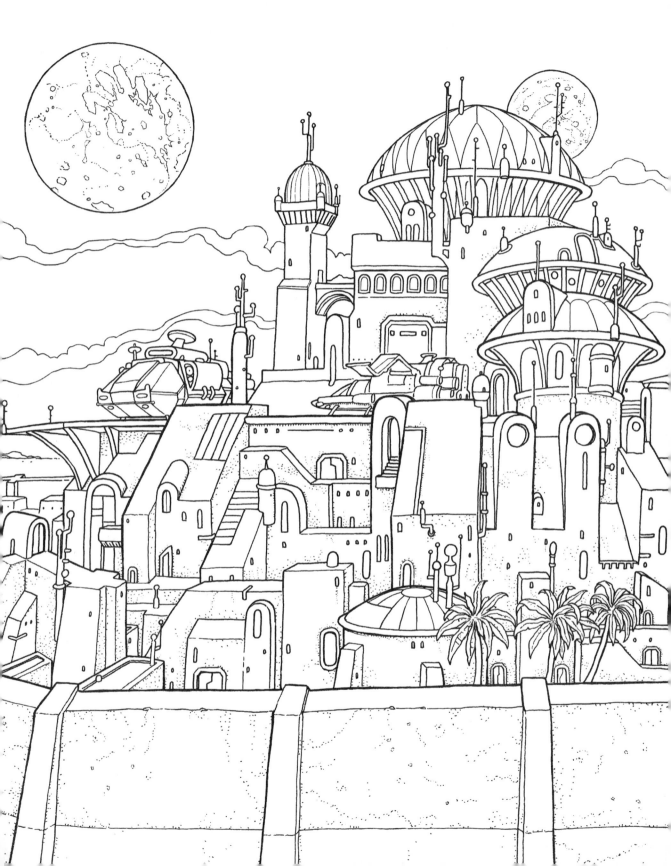

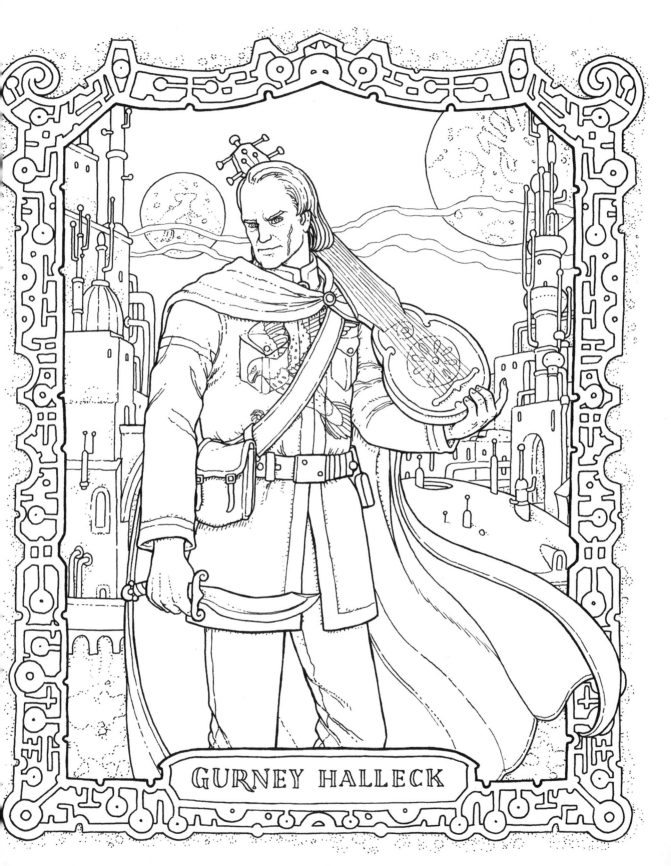

GURNEY HALLECK

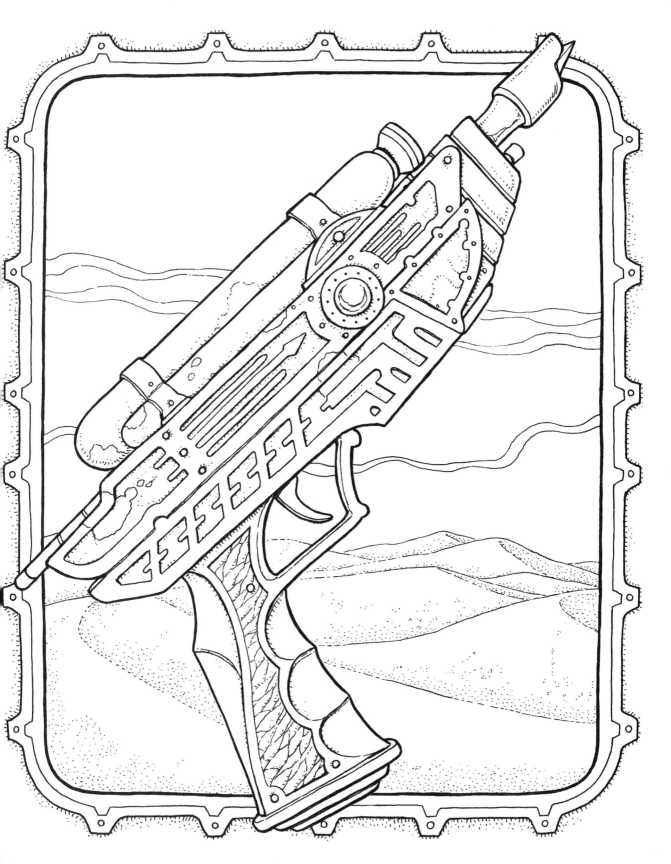

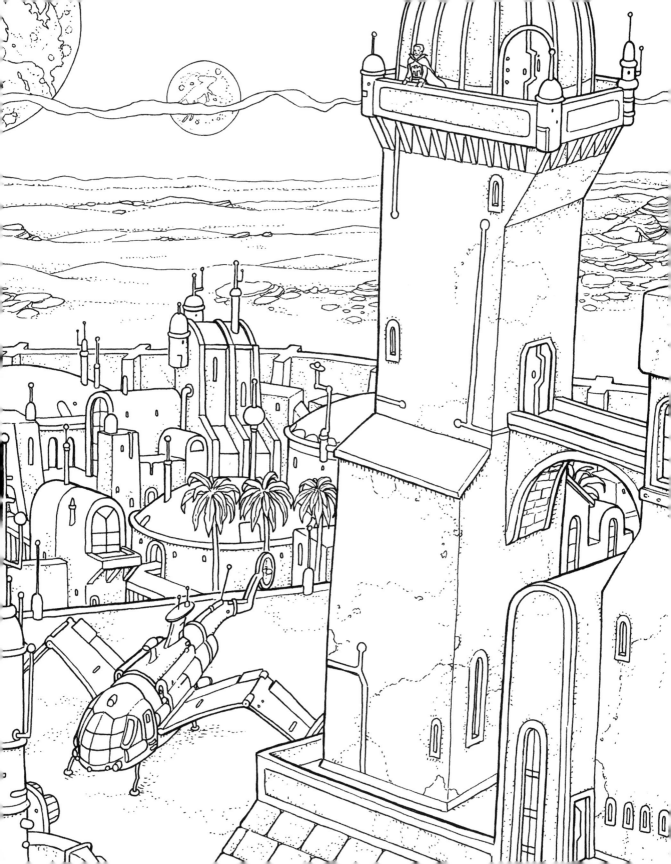

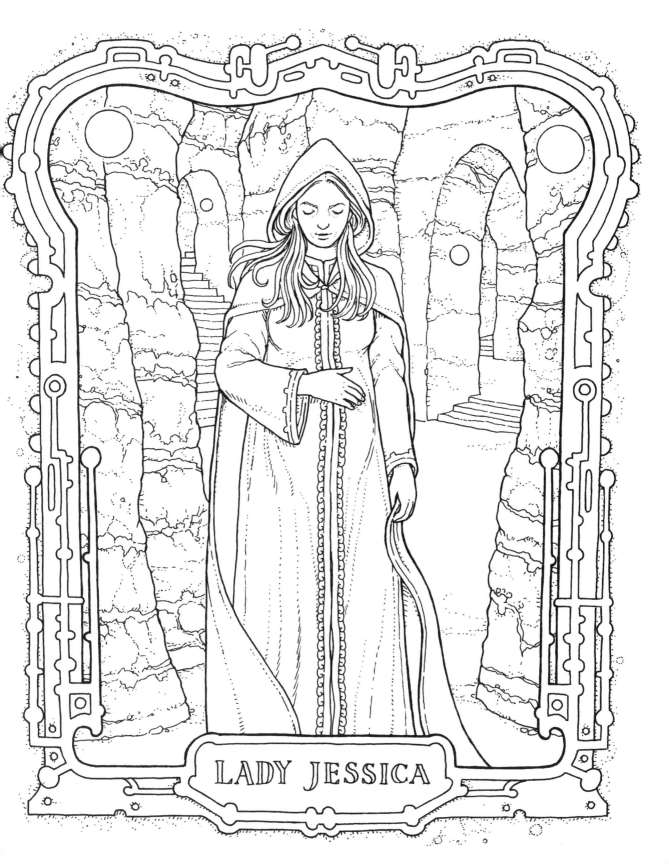

LADY JESSICA

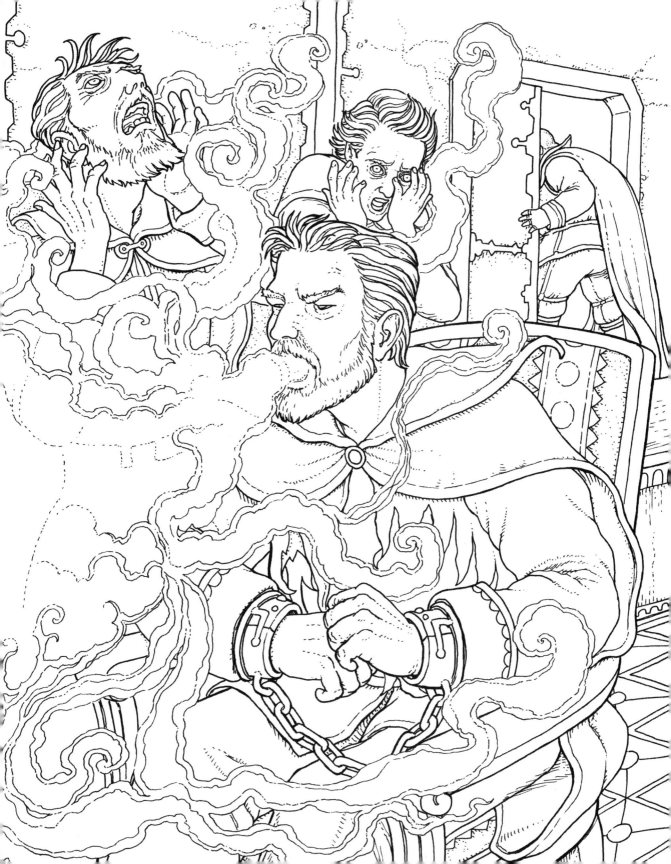

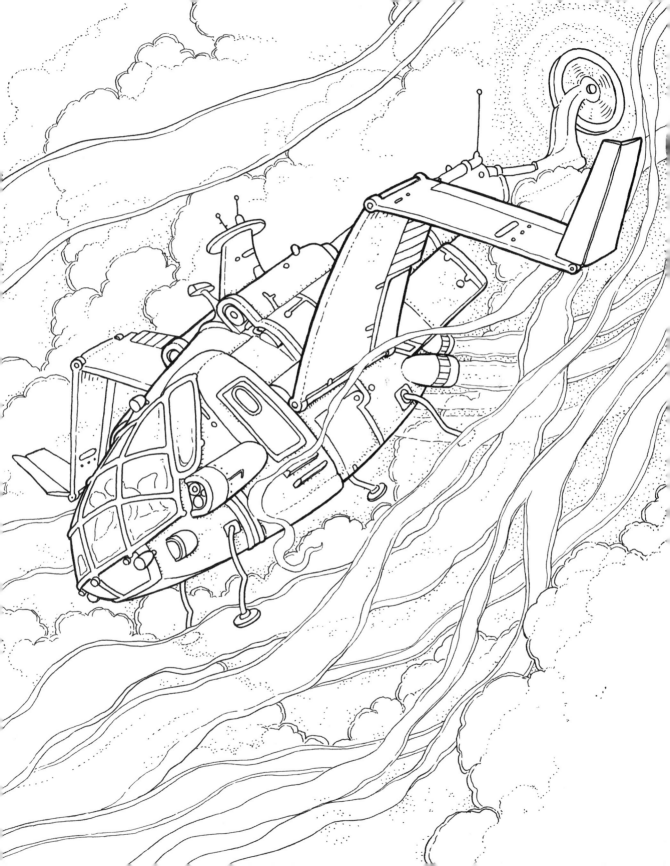

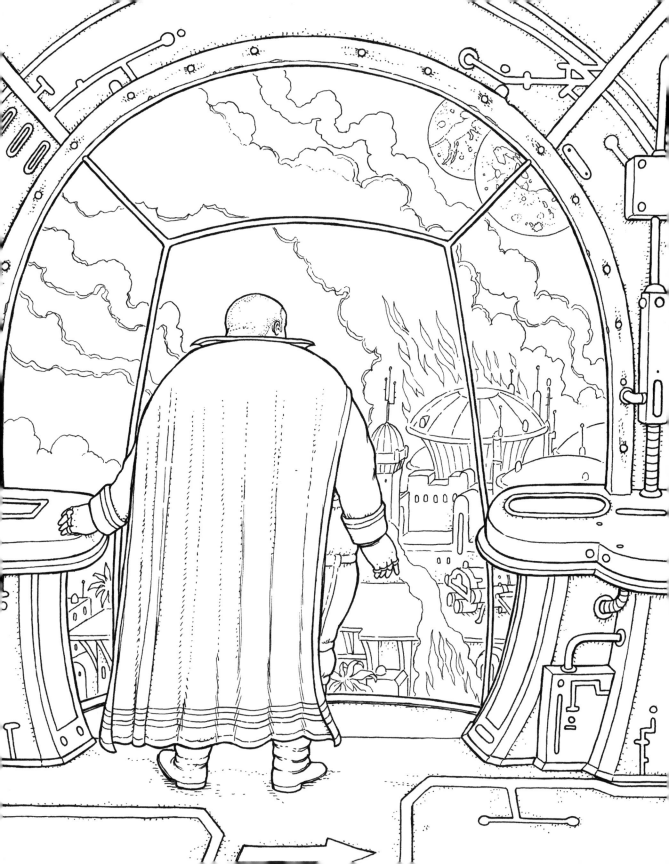

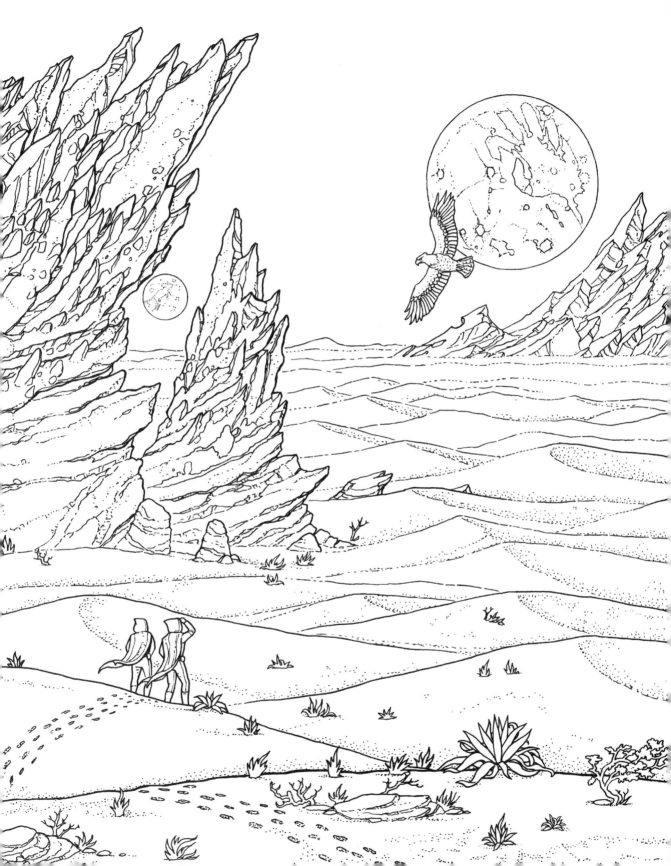

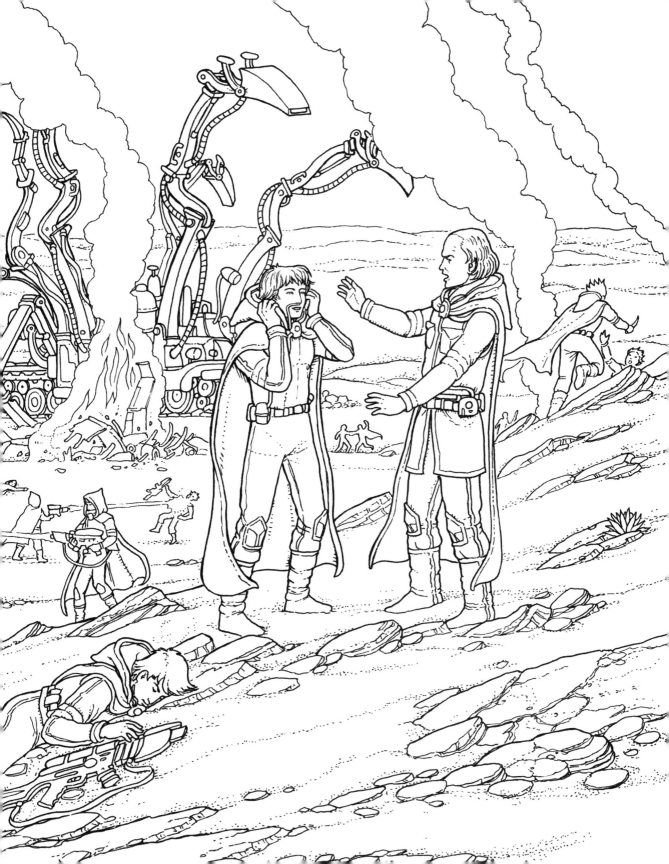

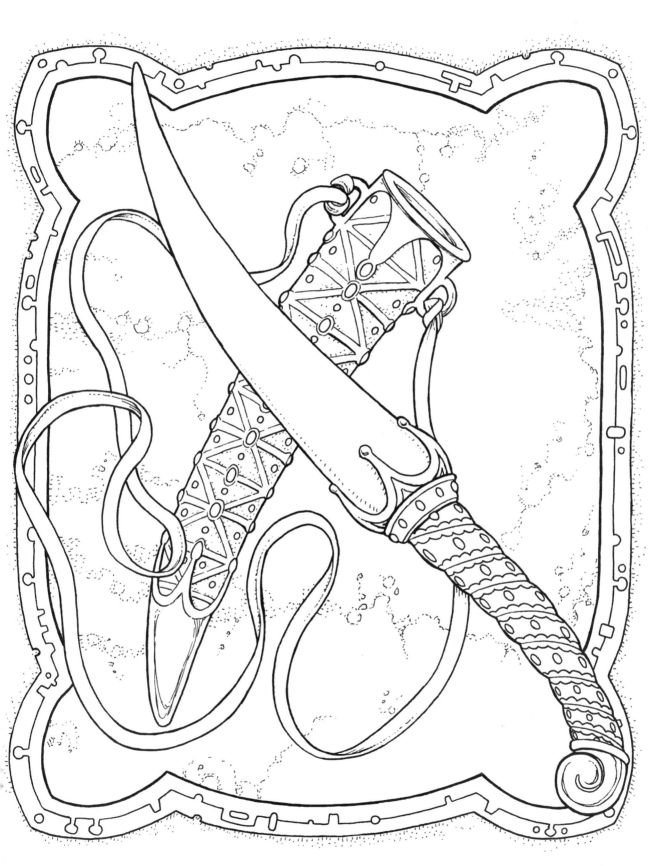

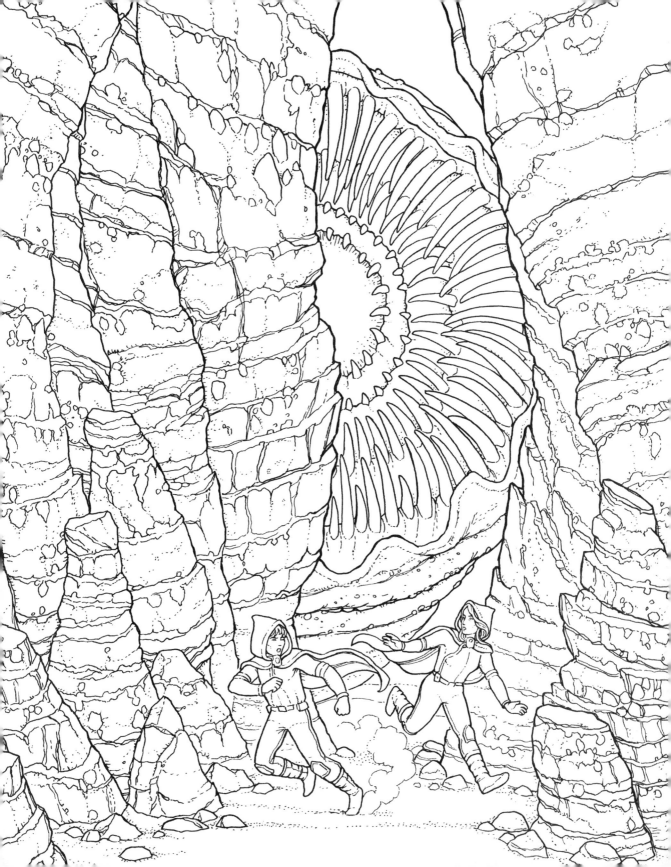

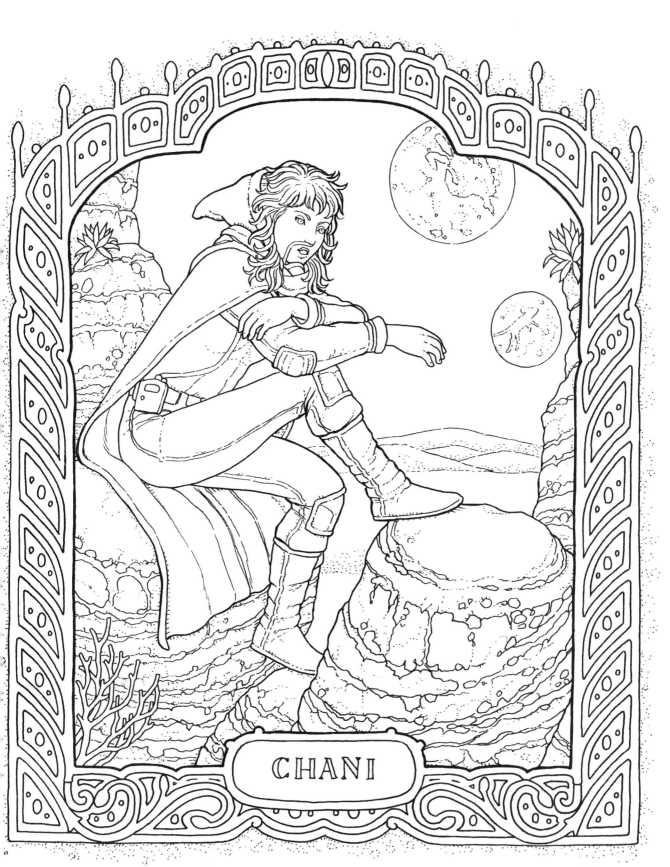

CHANI

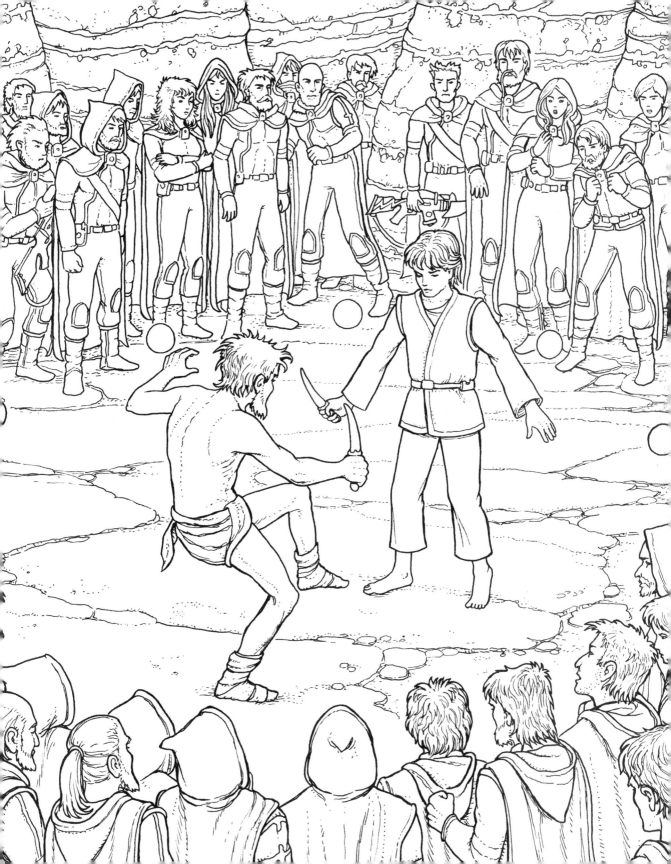

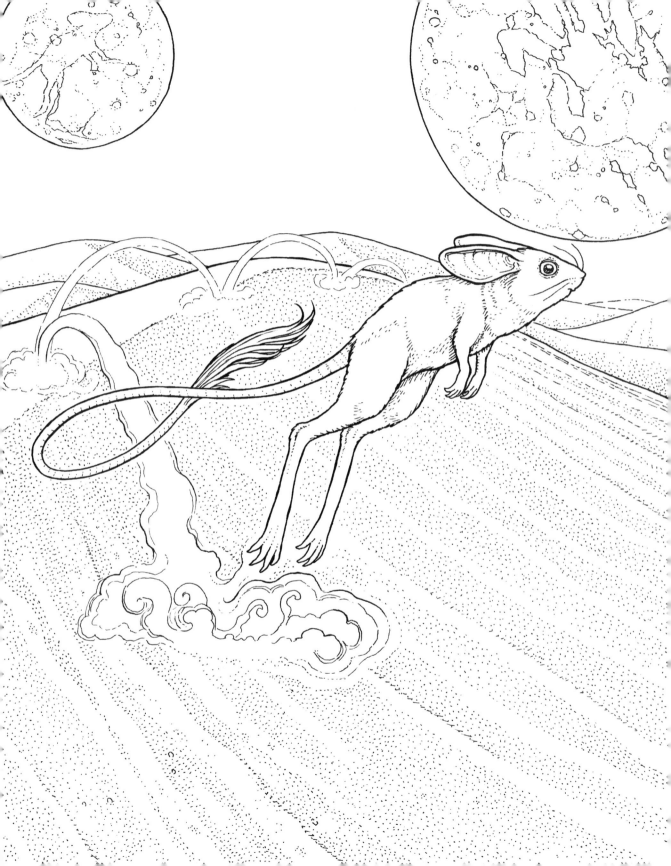

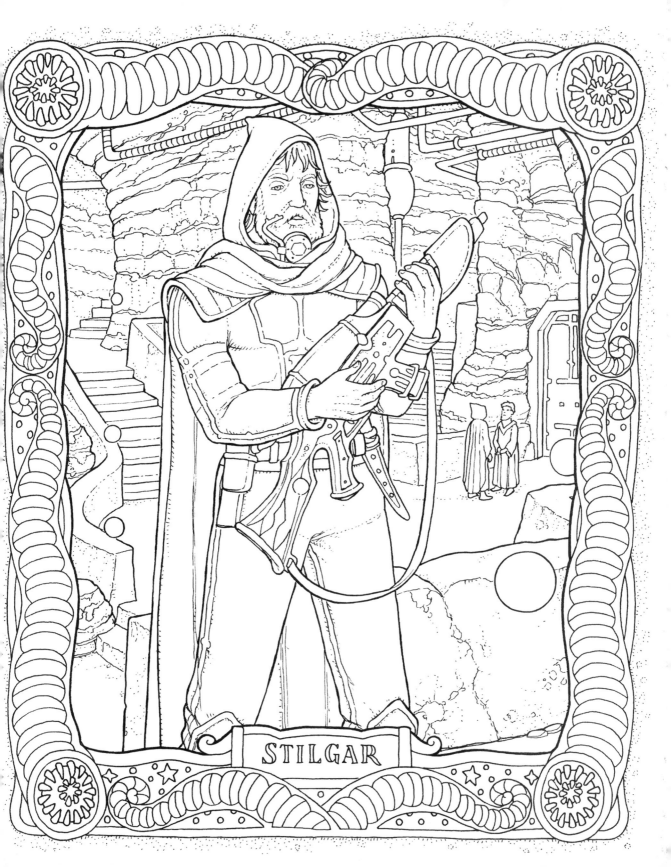

STILGAR

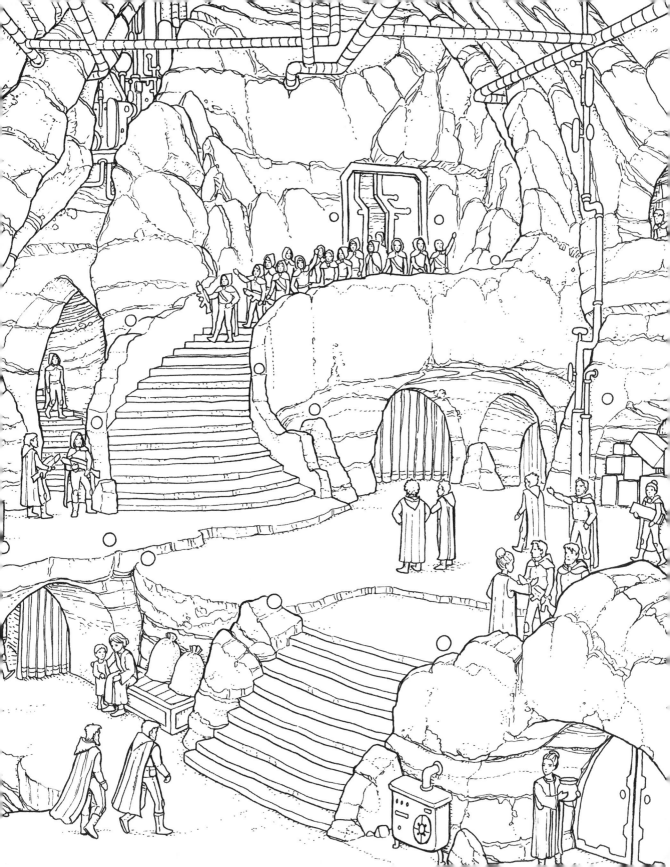

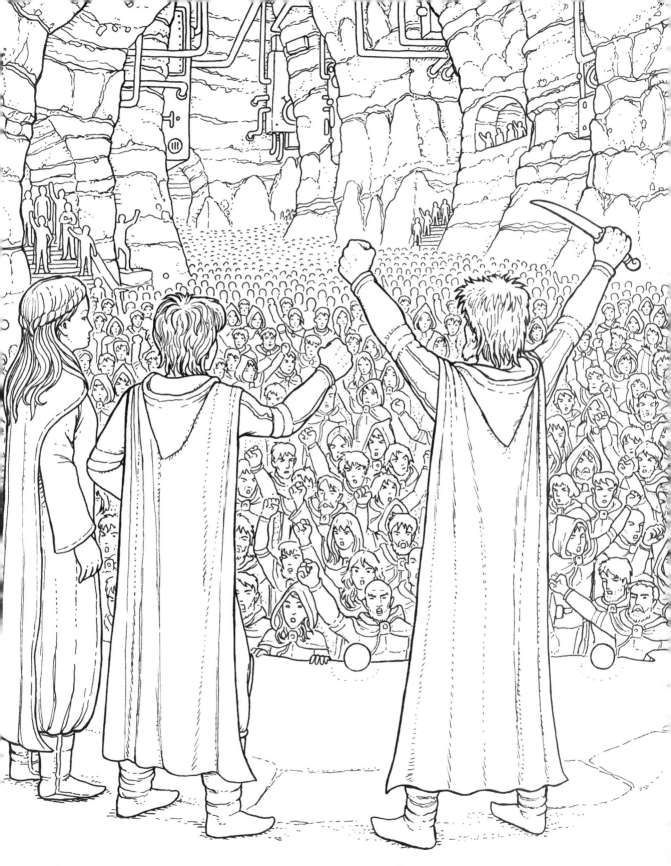

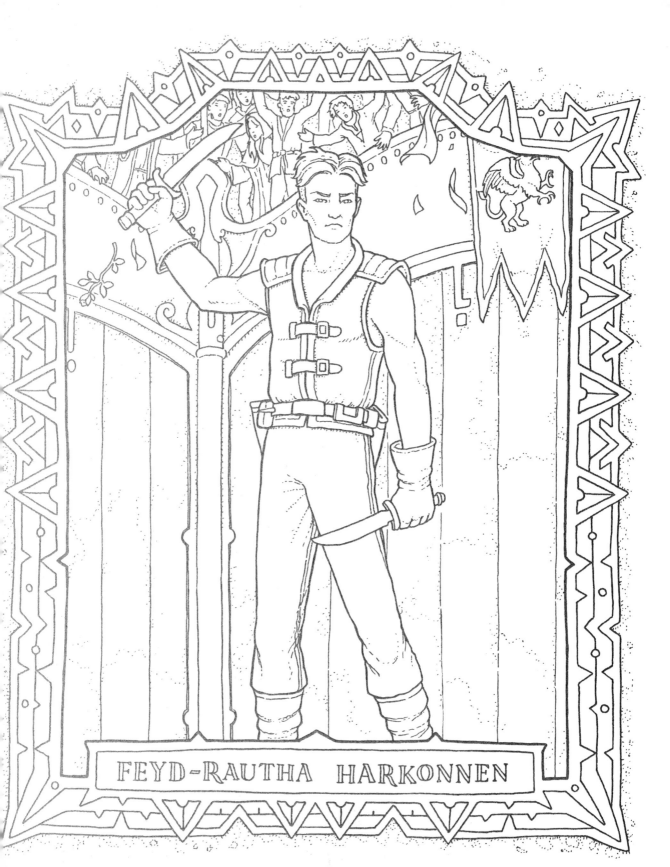

FEYD-RAUTHA HARKONNEN

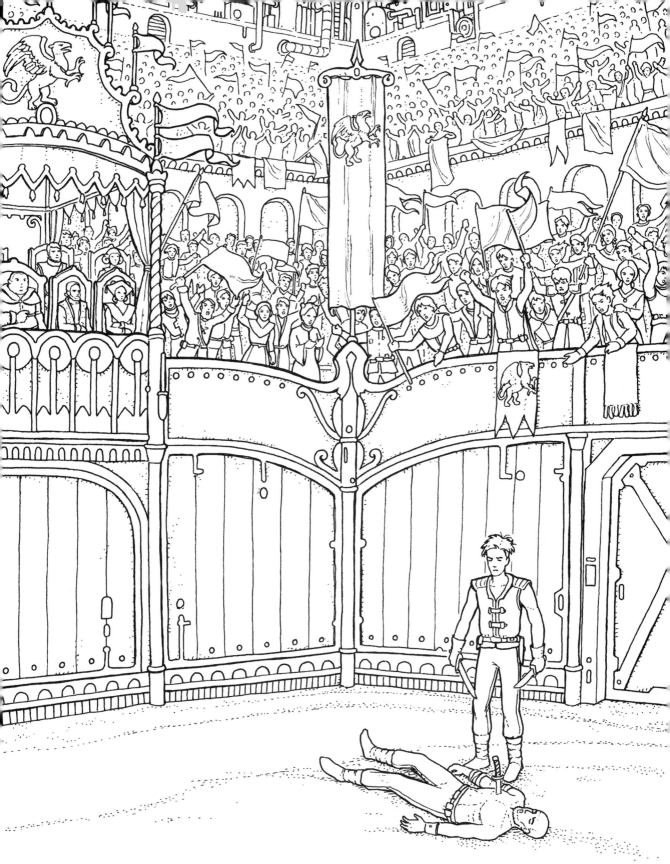

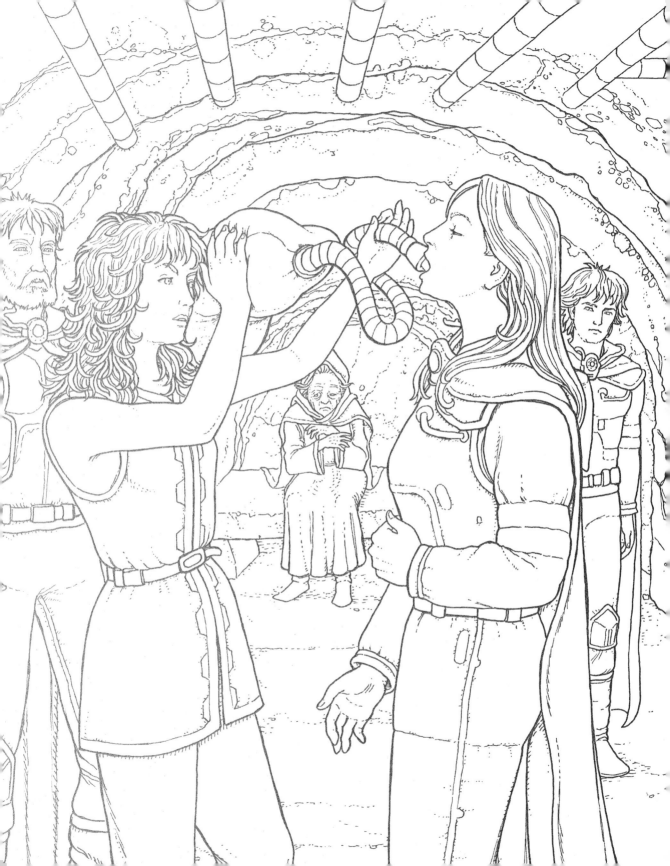

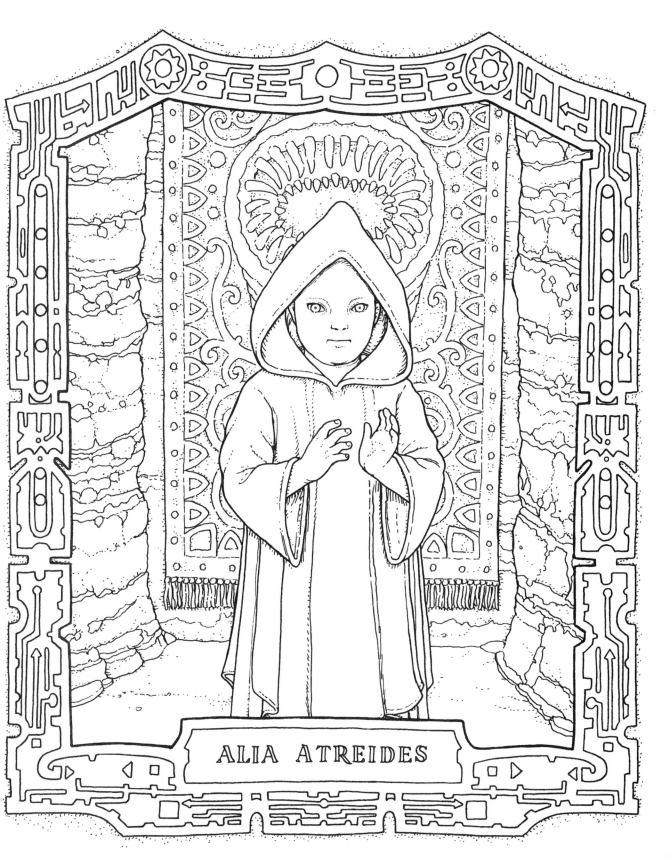

ALIA ATREIDES

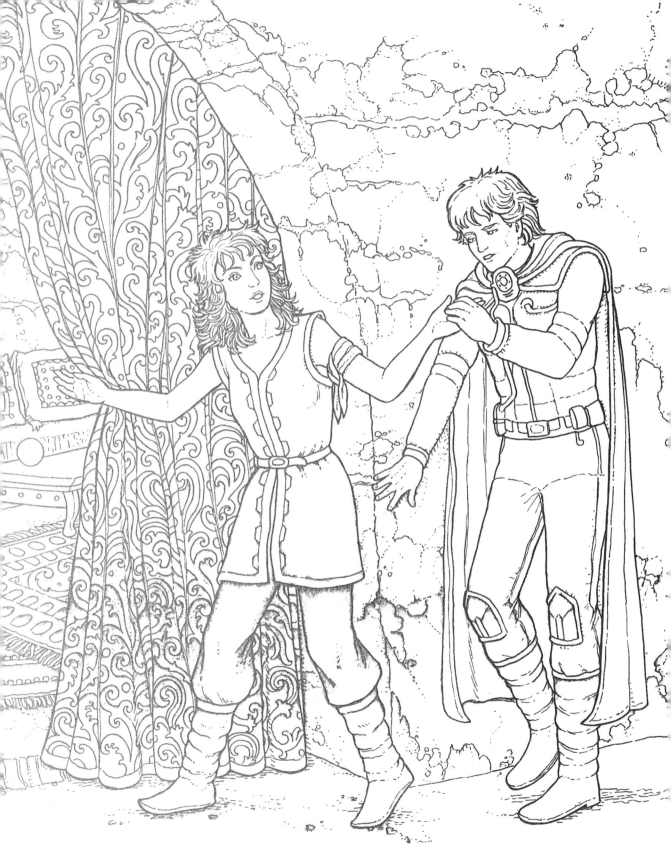

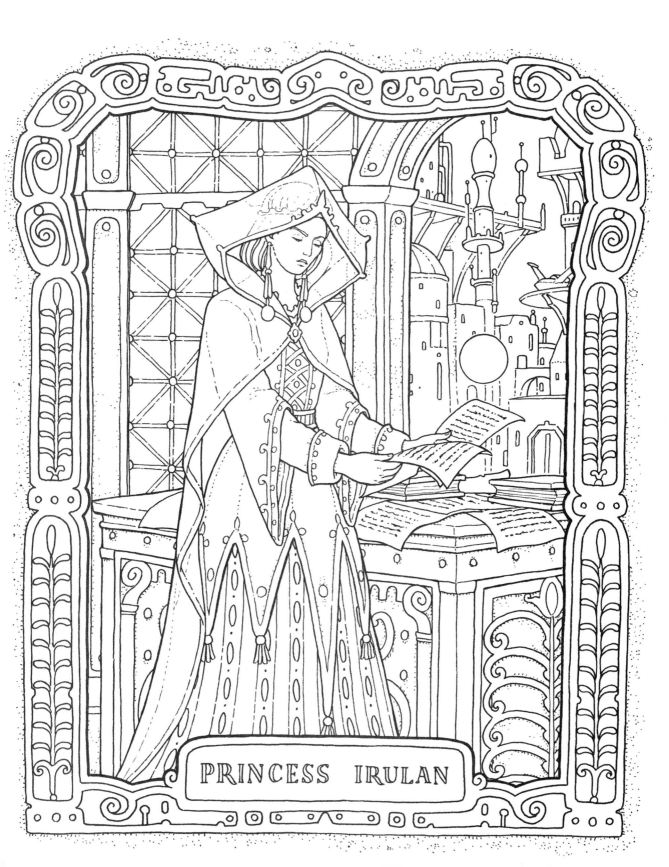

PRINCESS IRULAN

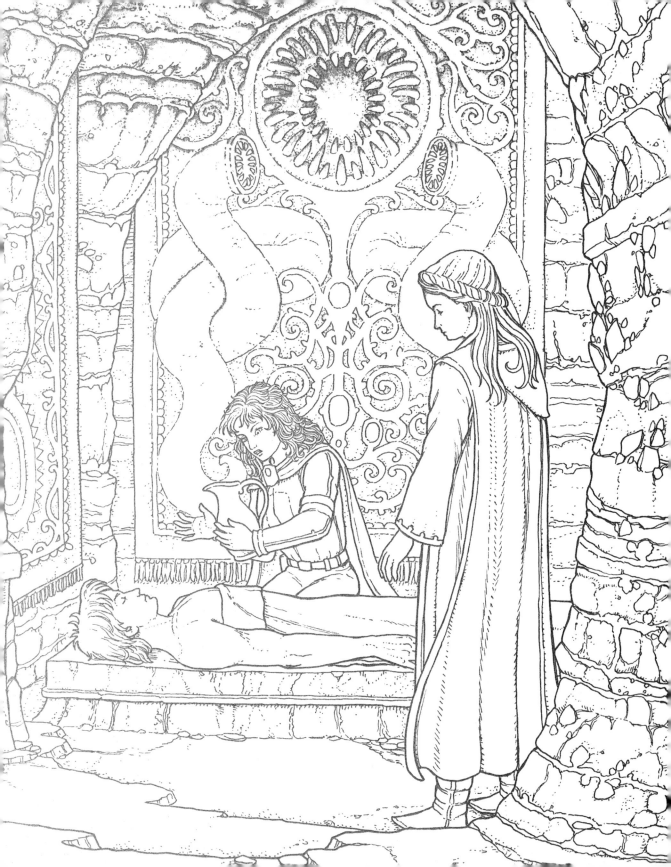

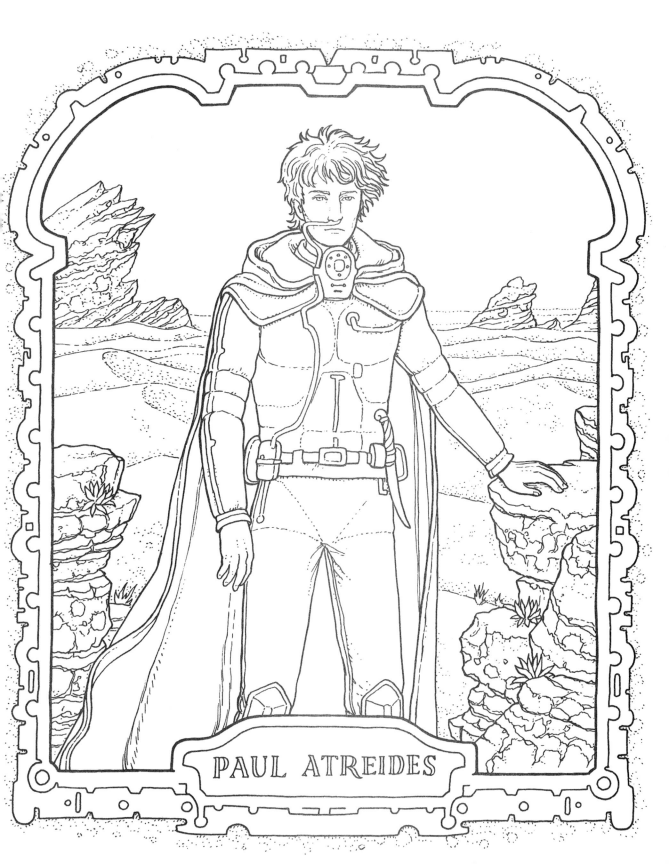

PAUL ATREIDES

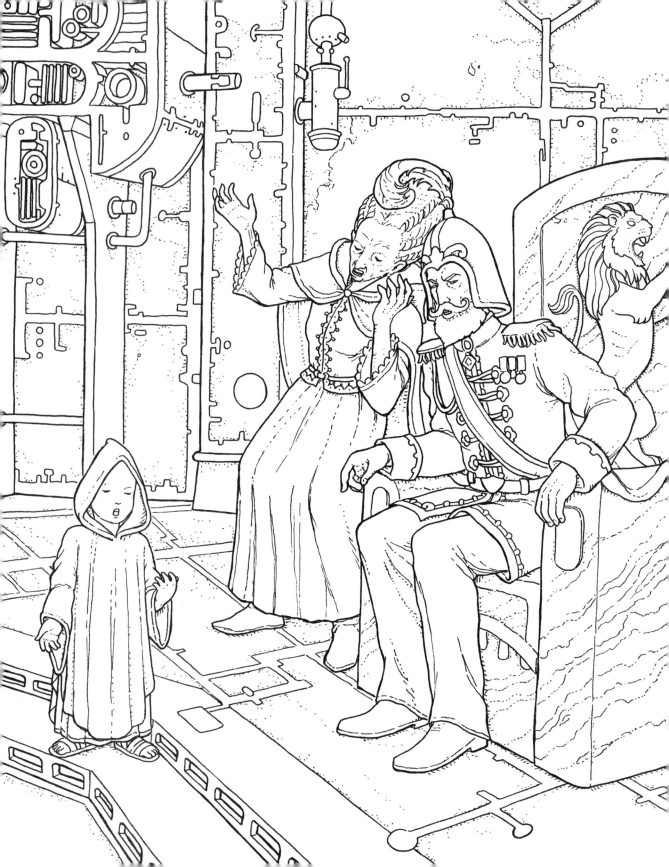

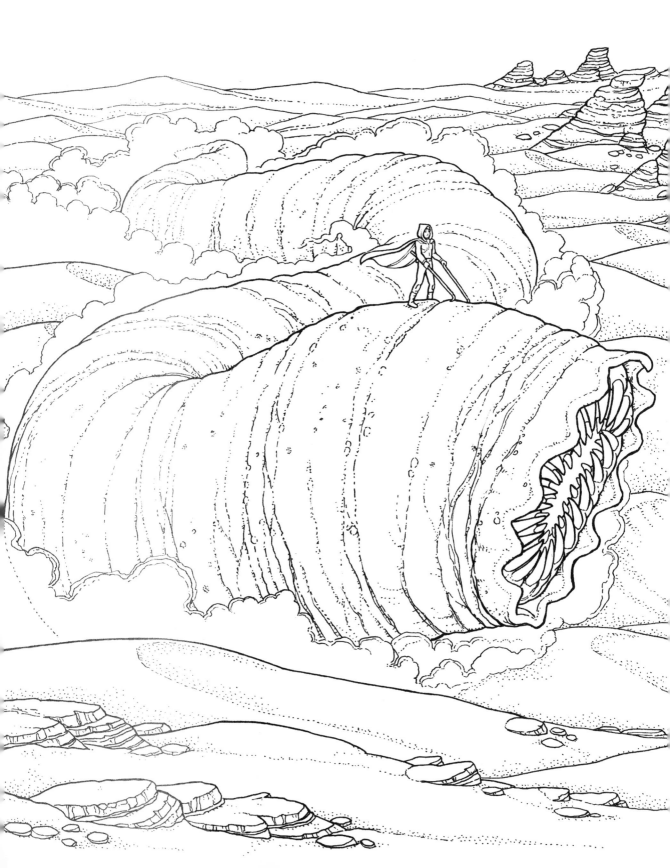

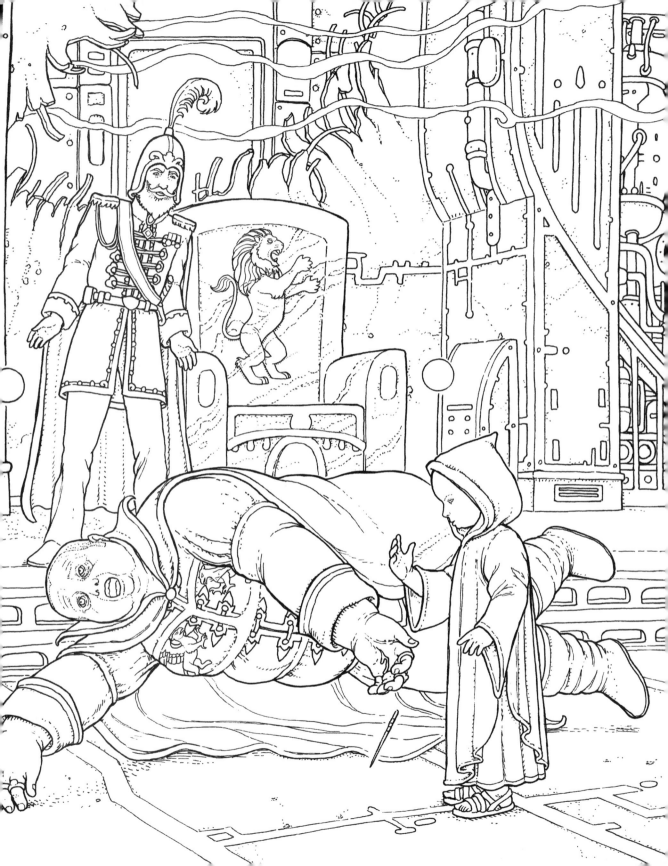

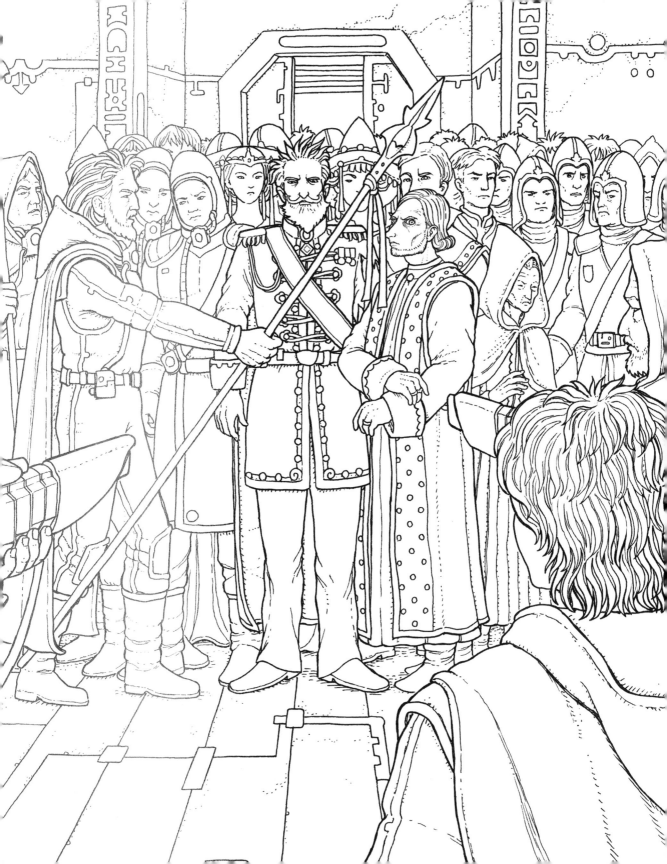

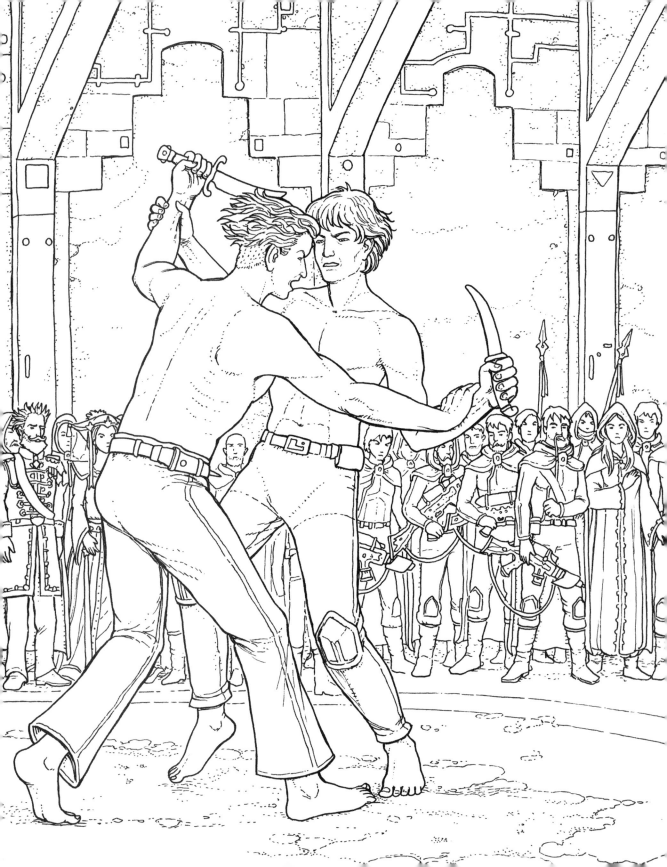

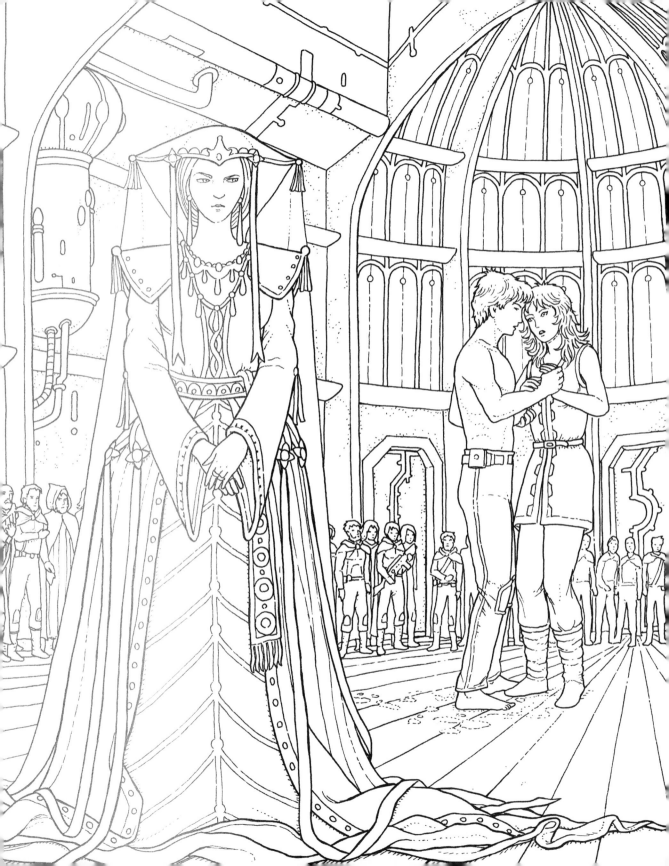

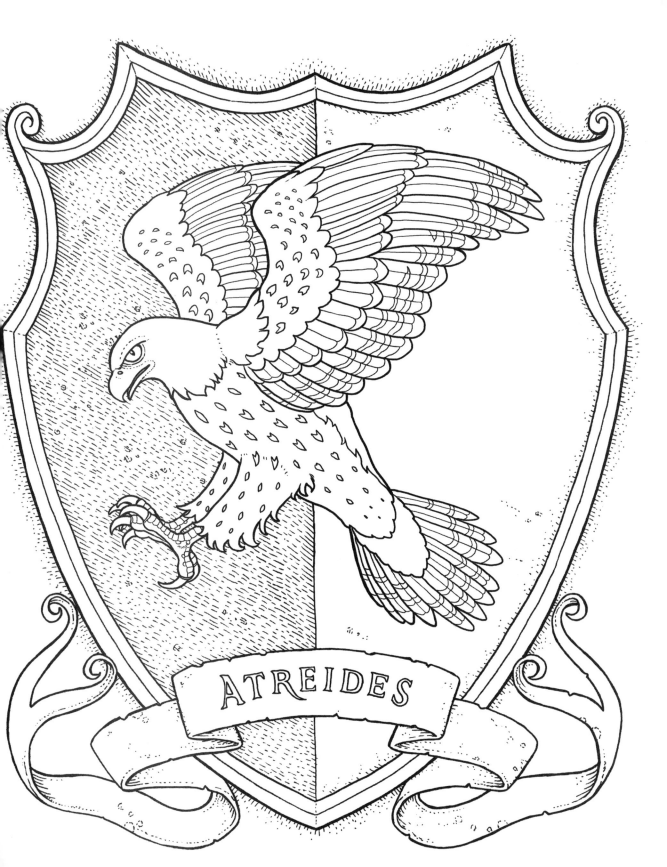

ACE

An imprint of Penguin Random House LLC

penguinrandomhouse.com

Copyright © 2023 by Herbert Properties LLC

Penguin Random House supports copyright. Copyright fuels creativity, encourages diverse
voices, promotes free speech, and creates a vibrant culture. Thank you for buying an
authorized edition of this book and for complying with copyright laws by not reproducing,
scanning, or distributing any part of it in any form without permission. You are supporting
writers and allowing Penguin Random House to continue to publish books for every reader.

Berkley and B colophon are registered trademarks of Penguin Random House LLC.

Library of Congress Cataloging-in-Publication Data
has been applied for.

ISBN: 9780593638231 (paperback)

Printed in the United States of America
1st Printing